CALLIGRAPHIC LETTERING
with wide Pen and Brush

Third Edition ❖
Revised & Enlarged

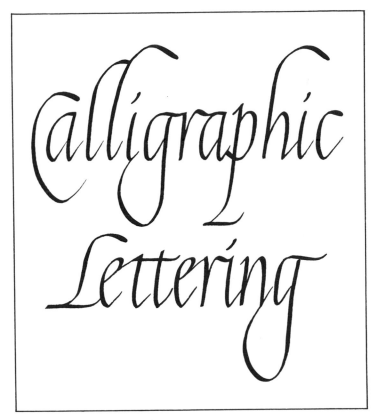

Calligraphic Lettering

with wide pen & brush

Ralph Douglass

WATSON-GUPTILL PUBLICATIONS, NEW YORK

PITMAN PUBLISHING, LONDON

Third Revised and Enlarged Edition
Copyright © 1949, 1962, 1967 by Ralph Douglass

Third edition published 1967 in New York by Watson-Guptill Publications
a division of Billboard Publications, Inc.
1515 Broadway, New York, N.Y. 10036

Library of Congress Catalog Card Number: 67-23532
ISBN 0-8230-0551-8

Manufactured in U.S.A.

First Edition, 1949
 First Printing, 1949
 Second Printing, 1955
Second Edition, 1962
 First Printing, 1962
 Second Printing, 1965
Third Edition, 1967
 First Printing, 1967
 Second Printing, 1968
 Third Printing, 1971
 Fourth Printing, 1972
 Fifth Printing, 1973
 Sixth Printing, 1974
 Seventh Printing, 1975
 Eighth Printing, 1976
 Ninth Printing, 1977
 Tenth Printing, 1977
 Eleventh Printing, 1978

To my Students

FOREWORD

AS NOTED in the first edition of this text, it was originally designed as a teaching aid. Following World War II, college classrooms were bursting at the seams with an influx of veterans. This work was published at that time from a sense of urgency. Now, after several years of using it as a textbook, I wish to revise the manuscript in the light of classroom experience, and to make certain improvements and additions which suggest themselves.

IT IS NOT the purpose of this book to make an original contribution to calligraphy. The author does not profess to be an art historian. On the other hand, neither is it intended as a collection of alphabet charts to be slavishly copied. Rather, the purpose is one of general education. It represents an effort to provide a sound elementary introduction to an interesting and time-honored craft, not only for the casual letterer but for the beginning calligrapher as well. There is a stimulation in creative lettering that comes only from a knowledge of principles and background. I hope, therefore, that this workbook will prove an inspiration as well as a practical self-help not only to the artist and student but also to the layman fascinated by lettering who desires to improve his penmanship.

¶ GRATEFUL ACKNOWLEDGMENT must be made to the following people for their good services, without which this work never could have been accomplished: first, to Arnold Bank, calligrapher, teacher and friend, who introduced me to a philosophy that makes creative lettering possible; to my colleague, Dr. Alexander Masley, professor of art education, who read the manuscript and made valuable suggestions; to my daughter, Marilyn, who lightened the labor of this undertaking by lettering the book-hand text on pages 25, 29, 33, 35, 45, 47, 53, 54 and 55; to my wife, who lent encouragement throughout and proofread the manuscript, an especially hazardous task when it is handwritten; to the University of New Mexico, for granting me a sabbatical leave in which to do most of this work; and last, to the staff at Watson-Guptill, for introducing the first edition to an art audience, and for again ably and courteously handling the arduous details of publication.

¶ THIS 1967 EDITION, in expanding the presentation of the Chancery hand, takes cognizance of the great revival of italic handwriting in Great Britain and the United States during recent years. The addition of late publications to the bibliography will serve serious students pursuing calligraphy in more depth. Again, my hearty thanks to professional colleagues & others mentioned elsewhere for their generous cooperation.

R. D.

CONTENTS

TOOLS AND MATERIALS for Pen Lettering

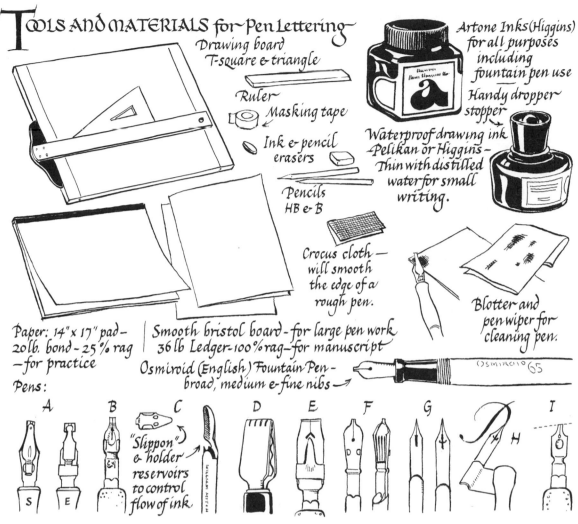

Drawing board
T-square & triangle

Ruler

Masking tape

Ink & pencil erasers

Pencils HB & B

Crocus cloth — will smooth the edge of a rough pen.

Artone Inks (Higgins) for all purposes including fountain pen use

Handy dropper stopper

Waterproof drawing ink —Pelikan or Higgins— Thin with distilled water for small writing.

Blotter and pen wiper for cleaning pen.

Paper: 14"x 17" pad – 20 lb. bond – 25 % rag – for practice

Smooth bristol board – for large pen work 36 lb Ledger – 100 % rag – for manuscript

Osmiroid (English) Fountain Pen – broad, medium & fine nibs →

OSMIROID 65

Pens:

A B C D E F G H I

"Slippon" & holder reservoirs to control flow of ink.

WILLIAM MITCHELL

S E

USE GOOD MATERIALS and keep your tools clean. When work is finished, clean ink from the reservoir with the corner of a blotter, as shown above. Then wipe the pen with a cloth, especially the underside. Whenever the ink does not flow readily, stop and clean the pen. You cannot do clean, sharp lettering with a dirty pen. ❡ Tools for brush lettering are shown on p. 53. For homemade tools see p. 56.

A. Speedball "C" Series & Esterbrook #18 or #19, for all wide-pen alphabets. B. William Mitchell "Cursive" pen, in sizes from small stub to 1/8". (Made in England. U.S. Distributor: H.M. Storms Co, 80 Roebling Street, Brooklyn, N.Y. 11211. C. Wm. Mitchell reservoir devices. D. Coit poster pen, sizes 1/8" to 1". Uses ink or poster paint. E. William Mitchell Poster pen, 12 sizes. Sharper than the Coit. F. Osmiroid reservoir pen, 3 sizes. (Storms.) G. Gillott #170 & Principality. See pp. 44 & 58. H. Elbow pen staff. I. Left-handed pen.

Always use a reservoir pen holder or "slippon" reservoir with W$_m$. Mitchell pens.

11

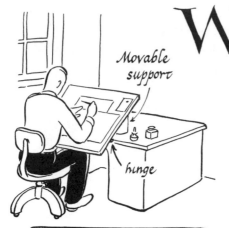

Movable support

hinge

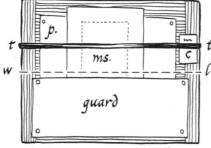

p.

t — ms. — t

w ------- l

guard

Wipe off a new pen with saliva
to remove the
oily film.

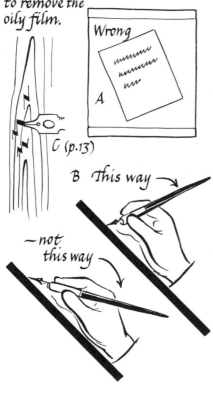

Wrong

A

C (p.13)

B *This way*

—not
this way

WRITING POSITION. The suggestions on

this page, all essential to good lettering,
can be followed by any unskilled person.
Take them seriously. ¶ First, sit well-
poised with the light source on your left,
ink at the right, or vice versa if left-handed.
The drawing-board should be at a fairly steep
slant, either resting on the edge of the table
and in the lap or hinged to the table and
supported by an object placed behind it. A
pad (p) made of several sheets of paper
softens the surface of the board. A guard
placed just below the writing line (wl) pro-
vides a rest for the hands and prevents soil-
ing the manuscript (ms.) or layout, which is
slipped underneath the guard and moved up as
the writing progresses. A rubber band or tape
(tt) holds the plate in place. A scrap of simi-
lar paper is needed for trying the pen (c).
¶ The lettering plate may be moved up or
down and from side to side but should not be
canted on the board (A). Be sure that your
paper is free of all dust and erasings before
beginning to letter. Do not clutter your
working space with unnecessary materials.
¶ The position of the pen in the hand will
vary, of course, with the individual. However,
for sharp, wide-pen letters the writing tool
does better when held at a steep angle with
the plate rather than too sloping (B). Do not
press with pen hard enough to spread
the stroke. Let the pen write.

PRACTICE STROKES. For your first work on any exercise or alphabet, a 1/8-inch pen is recommended. Use bond paper & thin ink. ❧ Begin at once with pen and ink without preliminary penciling. If the pen is new, moisten a tissue with saliva and wipe the film from it. Dip the pen in the ink. (When doing finished work, it should be filled with a dropper. See A.) Note instructions under B and C at the right. To start the ink flowing, move the pen sidewise. If it still refuses to write, try it on another piece of paper or with the grain of your drawing board (p. 12 C). ❧ Set the pen firmly but not heavily on the paper so that the entire edge comes in contact with the surface (D). If you lean the pen to the left, the right side of the stroke will be ragged (E) and vice versa (F). If the pen is held correctly, the stroke will be clean-cut on both edges (G). ❧ Breathing is important. When about to start a stroke, inhale; while the pen is in motion, hold your breath; when finished, exhale. ❧ In making a curve, glide into it and out as a plane would land and take off (H). Lift to the side at the end of a straight mark (I). Don't "whip" the strokes nor move the pen too slowly, but with deliberate freedom. ❧ Now, keeping the pen in a consistent position so that it makes a thin line at a 30-degree angle with the horizontal (J), try your hand on the strokes at the right.

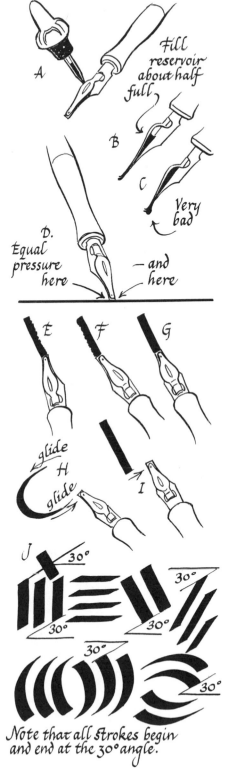

Note that all strokes begin and end at the 30° angle.

SIMPLE
ROMAN aabcdefgg

3 pen-width units

hijklmnopqrstuv

wxyz ABCDE

8 pen widths

FGHIJKLMMP

ONQRSTUVW

XYZ&.;:!?""'(–)

"Old Style" Numerals

1234567890

vs. "Modern"

1234567890

14

ON THE OPPOSITE PAGE is the Roman alphabet in its most basic, simple form, freely written with a broad pen held at a 30° angle with the horizontal (A). It has been good for twenty centuries and today is the most widely used in modern printing, attesting its excellent design. ❡ Like any fine alphabet, this one has been influenced from the first by the tools and materials used in its creation, always a sound basis for design. The letters here reproduced are the product of a straight-edged writing instrument which might be a quill, stylus, steel pen or other chisel-shaped tool. (See pp. 11 and 56.) In this case, when the pen moves at an angle of 30° with the horizontal, the stroke is thin (B-1); when it moves in a direction perpendicular to that angle, the stroke is thick (2). As a result, A is traditionally shaded on the right, V on the left (C). The width of other strokes, obviously, is determined by the direction the pen is traveling, the angle of the pen remaining consistently the same. In the curved strokes, the width changes gradually from thin to thick (D). ❡ The letters opposite are furnished as a guide to the form and theory of this alphabet. Do not copy their accidental faults. As you practice the following exercises, compare the capitals with the classic Roman on p. 32 and observe their basic form; the "small letters" with Caslon, p. 62.

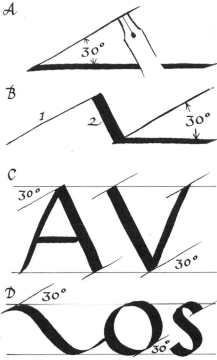

For blackboard demonstration, the teacher can use a short piece of chalk on its side to get the thick and thin strokes.

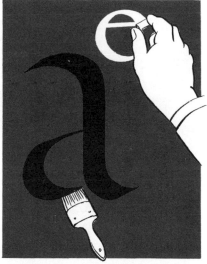

When the board is covered with chalk dust, use a wide brush with clear water.

SIMPLE ROMAN *Small letters in width groups*

In terms of "O"—

In pen widths —

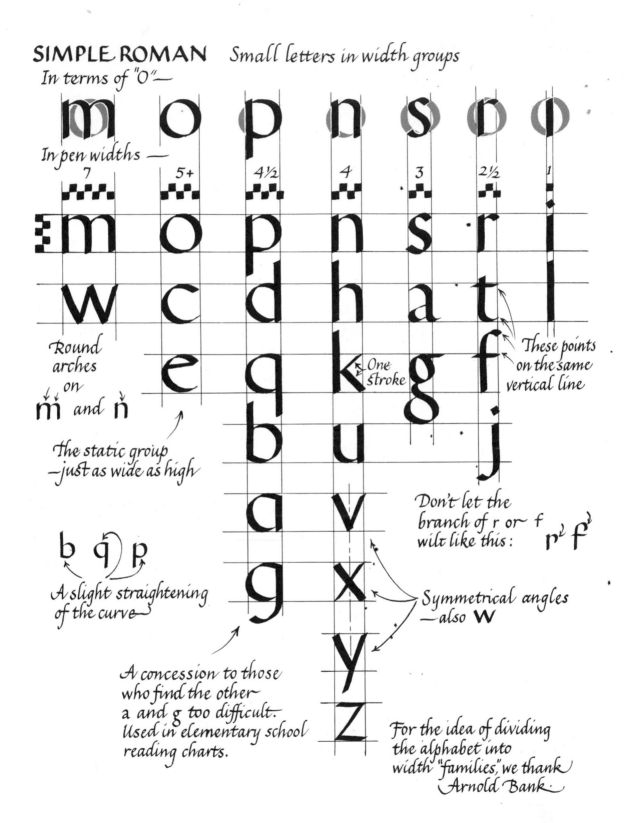

Round
arches
on
m̈ and n̈

the static group
—just as wide as high

b q̧ ρ̧

A slight straightening
of the curve

A concession to those
who find the other
a and g too difficult.
Used in elementary school
reading charts.

One
Stroke

These points
on the same
vertical line

Don't let the
branch of r or f
wilt like this: rᵛ fᵛ

Symmetrical angles
—also **w**

For the idea of dividing
the alphabet into
width "families," we thank
Arnold Bank.

ROMAN SMALL LETTERS, called also "lower case" or minuscules, present less difficulty for the beginner than the capitals because the strokes are shorter. Therefore we begin with them. If you have practiced the strokes shown on p.13 it should be easier to handle the pen on the letters. ❡ Small o can be taken as a standard of measurement in studying the proportions of the other letters. It is static in shape, a perfect circle on the outside, five times the width of the pen both laterally and vertically, plus enough to let the curve just cover the line. C and e are the same shape. In the p group, each letter has a vertical stem which cuts the circular body as a chord. Give special attention to the arches of m, n and h to make them beautifully round. The diagonals of k are made in a single stroke, not lifting the pen. Study marginal notes on g, a and e. Base the form of s, both small and capital, on two circles, which keeps it narrow and harmonious with the round o. The cross bars of t and f are asymmetrical, being longer on the right. ❡ On p.20 is a discussion of vertical dimensions and suggestions on how to rule your guide lines. After your paper is prepared, work diligently on the exercises shown on p.22 with the lower case before taking up the capitals. Don't make a whole line of one letter or copy the alphabet as such. Always use the letters as in words.

Trouble makers below!

Get the "o" ROUND —
so: O not so: O

Do NOT move the first stroke down — swing it back and down.

Then begin in the wet — and finish the job. 1 2

Inverse twins: Also twins, but different: d p
q b Note in these four letters that the circle would come outside the stem if completed.

Tail begins here —not here
Fairly sharp
Axis of oval = shaped upper loop 2
Relative size of loops 3
1
Axis of oval lower loop

Modern vs. Old Style
e e
a a

Try both ways
2 1
1 3 3
3 2 S S

SIMPLE ROMAN

Capitals in width groups

In pen widths:—

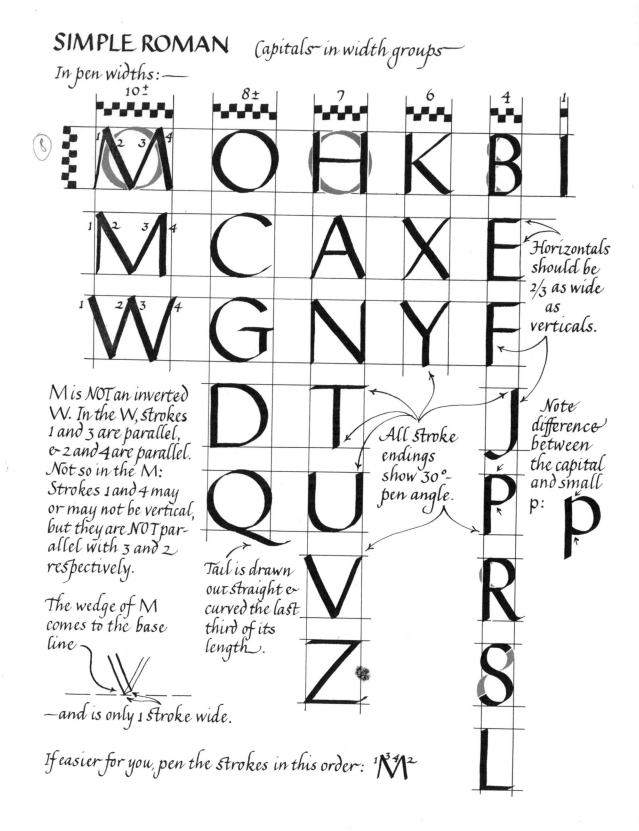

10± 8± 7 6 4 1

M O H K B I

M C A X E

W G N Y F

D T J

Q U P

V R

Z S

L

Horizontals should be 2/3 as wide as verticals.

Note difference between the capital and small p: P

M is NOT an inverted W. In the W, strokes 1 and 3 are parallel, & 2 and 4 are parallel. Not so in the M: Strokes 1 and 4 may or may not be vertical, but they are NOT parallel with 3 and 2 respectively.

The wedge of M comes to the base line

—and is only 1 stroke wide.

Tail is drawn out straight & curved the last third of its length.

All stroke endings show 30°-pen angle.

If easier for you, pen the strokes in this order: M

The ESSENTIAL FORM of the capital letters on the opposite page is based on the classic Roman of the Trajan Column. (See p.32.) Observe the sound design logic that has influenced these forms. The basic shape is the static circle or square. We have shown in gray the relation of some of the counters to the O-shape. (The space within any letter is referred to as the "counter.") If the double counters of E, B and S are to be static in form, then the width of the letter must be only half that of the big O. This gives at once a harmony of shape with a variety of width, both making for pleasing design. The angles of the A, V, N & Z are approximately 45°. X and Y, with their half-diagonals, must be less wide in order to use a comparable angle. ❡ The capital is eight pen strokes high, less than the lower-case ascenders. This makes for a change in height compatible with an even tone over the page by minimizing the accent effect of the caps. ❡ As with the small letters, the Roman Capitals are also created with the pen held consistently at a 30° angle with the horizontal, which shows at the end of every stroke. Exceptions (shown on the right in gray) are made in the case of N, M & sometimes Z, when the pen is manipulated to suit the desired width of stroke in these cases only. ❡ For practice, follow the exercises suggested on p. 23.

B = 2DS

When too wide, the shape becomes inharmonious & ugly

Don't get into the rut of making all letters the same width:

BOOK

Although uniform letter width is used in condensed types and italic, the greatest dignity is achieved by following the classic proportions found on these first pages:

BOOK

The letter S is based on two circles, wide stroke in the middle

S

← Not like this, which is made from "flat" pen position

Tails branch NEAR the stem.

K R

Variations from 30° pen angle:

M N Z

19

VERTICAL PROPORTIONS ·

Measurements below are in pen-width units. For instance, Esterbrook #18 & Speedball C-1 pens call for 4-5-3 units that would measure ½ in. – 5/8 in. – 3/8 in.

~AT FIRST, letter with the aid of three lines, spaced as indicated below. Do this at least until you get well acquainted with the alphabet. Sometimes the old scribes got along with one line.~

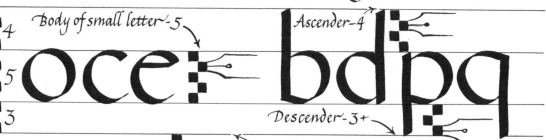

4
Body of small letter – 5
5
3

oce

Ascender – 4

bdpq

Descender – 3+

Note that there is no space left between lines.

CAP

Capital – 8 pen strokes — one less than for l.c. ascender.

SMALL t is shorter than the other ascending letters; and descenders, such as that of g, may be extended beyond the 3-pen-stroke zone if circumstances permit. Points and curves of letters must overlap the line a bit to appear to be on it. ¶As a labor saving device, rule a master sheet with black lines that will show through your practice paper. Then fasten the two sheets together with masking tape so that they will not slip. You will need a different master sheet for each pen width. ¶ The proportions here described are for medium-weight lettering & should be thoroughly felt before going in for variation. Later, a bolder (blacker) or lighter "weight" may be used to suit the subject matter by varying the width of the pen ·

Masking tape

4
5
3
4
5
3

↳ *Could be ruled either horizontally or vertically.*

MEDIUM ⦂ BOLD ⦂ LIGHT

THE ROMAN ALPHABET broken down into PEN STROKES

AA BBB CC DD E

GG HJKL MM

NO QRR SS TU

UVW X Y Y Z

aa bb cd de ff g

gg h hij j kk l mm

nn oo pp q rr sst

uu vv ww xx yy z

✳ Good Lettering is more a matter of Freedom & Beauty than of Precision ✳

PRACTICE SUGGESTIONS · ·
Consistent with the above stated principle, no precise draftsmanship is claimed for the wide-pen alphabet charts in this book. The pages were designed and freely written with a minimum of pencil layout and re-touching. The text was written directly with pen & ink, as the old scribes wrote their books and as you are expected to "write". Remember that a properly handled pen will not only create the letters but will help you space them.

True freedom, however, exists only where there is discipline. It is said: "You, too, can be a calligrapher if you have perseverance & live long enough." The only way to acquire skill is thru tireless practice. Do not try to master the letters separately. Write them as in words, using the exercises below or like ones. Keep the spaces the width of a small o. Practice direct-ly with the pen on bond paper. Watch your breathing. (See p. 13.) Make dozens of copies. Stop after each page to check form & proportion.

1. Using a ⅛" pen, take the small letters in width groups: (See p. 16.)

mw oce pdqb nhkuv

xyz sag rtfj il mw oce etc.

2. Then take them across the chart, so:

mopnsri wcdhatl eqk etc.

3. Now write an alphabet sentence, leaving the width of small o between words:

a quick brown fox jum

Or: "pack my box with five dozen lacquer jugs."

ps over the lazy dog etc.

Having acquired some confidence with the "small letters,"
now try the capitals in similar exercises: (See p. 18.)

4.

MMW OCGDQ H etc.

5.

MOHKBLMCAXE etc.

6. Another alphabet sentence:

BRAWNY GODS JU

ST FLOCKED UP to quiz and vex him, etc.

Now mix the capitals and small letters:

(If the vertical
gives you trouble
rule an occasional
line to check by.

7.

Able Baker Chas. etc.

8.

Active Atomic Ash B

etter Baked Beans Ca etc.

THE LINE or page of handlettering should be so spaced as to present an even tone. Spacing is not a matter of mechanics but rather of feeling and taste. If the letters are set mechanically and spaced equidistant from each other, the effect is uneven and bad:

Same measure between points

Note crowded condition here

BAD SPACING

Too much space

Note open spaces

FOR an even appearance & maximum legibility, the white space within and around the letters must be considered and weighed as in any other kind of all-over design. Note again that the average space between words is approximately the width of small o:

In good spacing, determining the distance between letters is a matter of feel

CORRECT SPACING

TO implement good spacing of letters within the words, follow this "rule of thumb":

The greatest distance is left between two straight strokes → **II** *as in* **HILL**

A curved stroke next to a straight one is a little closer → **)I** *as in* **JOIN**

Two curved strokes are still closer → **)(** *as in* **BOOK**

Two points are placed as close together as possible **CALVERT** *A point or curve can be tucked under*

FOR decorative purposes, letters are sometimes spread out:

L E T T E R S P A C I N G

LAYOUT is just another name for orderly arrangement or design. In typesetting or lettering, the elements of design are the lines of letters, blocks of texts and accents (such as initial letters and spots of black or color). Balance may be formal (see 1 and 2 at the right) or informal (see 3 and 4.) Subjects suggesting formality, dignity and such qualities call for formal balance. Where movement and liveliness are indicated, use informal balance. ¶A layout can be tied together by the use of vertical and horizontal or diagonal axes. (See 3, 4 and 6.) A happy medium should be struck between the two trends illustrated in 5 & 6.

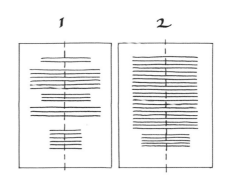

1 2

3 4

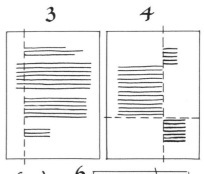

On the one hand: 5
 Statics
 Verticals & horizontals
 Large areas
 Even middle tones
 Unifying devices

On the other hand: 6
 Dynamics
 Movement, diagonals
 Broken areas
 and edges
 Contrasts
 Variety

IN MANUSCRIPT writing, certain traditional arrangements, based on sound principles of design, prevail. Margins vary but usually relate to each other as indicated here in unit widths. Use only 4 to 8 words to the line. See pp. 30 and 31.

general rule

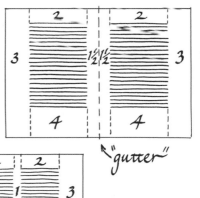

Double page →

"gutter"

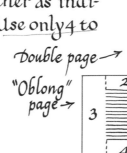

Single "upright" page →

"Oblong" page →

BOOKHAND

a ace bdf gg hi

optional

Pen widths

Bracketed serif may be used in a formal hand

j k l m n o p q r s s

D E G H M K N T

These Uncials

t u v w w x y y z ❖

go well with the capitals below.

A B B C D E F F G

8 pen widths

H I J K L M N Q

P R S T U V W X Y Z & &

BOOKHAND is perhaps the most common written variation of the Roman and also the most beautiful in its simplicity. It derives from the basic form which we have studied, adding a hook to most of the stem endings. On p. 13 (I) it is pointed out that a smoother end may be given the stroke by lifting the pen to the side. This easily develops into a hook & explains that feature functionally. The writing instrument in the hand of a skilled penman creates many such happy accidents. ❡ However, such features as the "hook" can be done beautifully or otherwise. Entrances at the top are usually small, whereas the exit hooks of h, m, n, i and l can be quite broad. But, large or small, make them round. ❡ It is legitimate to elongate tails or other strokes for decorative purposes or for filling out a line.

Ascenders and descenders respectively may be extended on the top and bottom lines of a paragraph.

Study the curve of any extended stroke and avoid weak or awkward lines. Whether long or short, draw out the tail of K, R or Q straight for two-thirds of its length and then curve it. But shun "tailiness" & overcrowding. ❡ After practicing, try bookhand on a quotation in manuscript style. See pp. 25 & 30 & 31.

Hooks — small or large — make them ROUND — like the arches

Not so

illm

The bracketed serif:
30°
Not too much curve

Watch i and l: Not a reverse "S" like this — but like this

hook
Straight
hook

Straight
30° plus
Solid triangle small
Broad curve

t d

Evolution of the letter a

Permissible flourishes:

A A A a a

Straight & curved on the end

Loops may be round, or flattened on the broad stroke

ROMAN
WITH SERIF

Stop short of line and fill in to make wedges sharper.

BCDGJKLQ

A flick of the pen held more vertically

PTUXYZ a

Serifs one way on lower case heads

bcdfhijklmn

Note this hook on d and u only

pqrsuvwxyz

Unchanged: egott

THE SERIF has had several functions in the history of writing and printing. The Romans devised a serif for use on incised letters to produce a more satisfactory shadow (A). Scribes found it a convenient way to terminate a stroke and to start the flow of ink on the heads. In modern type, various kinds of serifs still serve as the stem terminals. Some contemporary & popular faces abandon this feature entirely. See p. 61.

On the opposite page, all serifs are produced calligraphically and directly with the wide pen, including the more formal bracketed style in "Roman". Note, at the right, hints on manipulation of the pen. The letter itself is still written with the pen at the 30° angle but on the serif the angle is slightly "flatter". A 45° angle, on the contrary, produces a heavy looking letter. See H. Serifs are kept rather severely straight. A page of wiggles can get very tiresome.

The flow of ink from the pen is promoted by a slight connecting of one letter with the preceding, as in "ornate". As a space-saving device or for a packed effect, o's can be looped as in "book". Curved strokes may be frozen together but, in doing so, overlap them completely so that the "frozen" parts do not make a black spot on the page.

Again, practice this new hand not as an alphabet but in exercises and sentences. Try to do it beautifully.

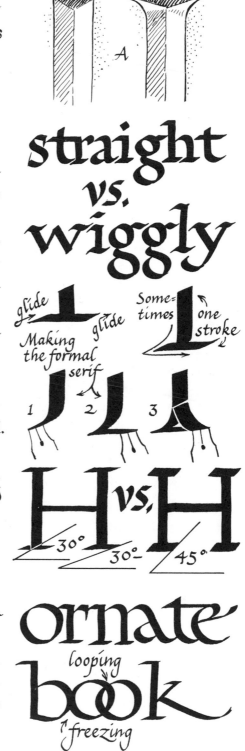

A

straight
vs.
wiggly

glide Some- one
 times stroke
glide Making
 the formal
 serif 1 2 3

H vs. H

30° 30° 45°

ornate
looping
book
freezing

Write a long manuscript as you would a letter, concentrating on fine letter-forms and keeping size and spacing as consistent as possible. When a line needs exact placement, make a trial run and put it just above that line on your final plate, as shown here: Always use a reservoir with the pen.

CENTRAL

CEN

A sk

K nock

S eek

Writing can be beautified by the rational use of simple decoration. Use one kind of ornament for one manuscript.

A safe way to devise ornaments is to use the same wide pen employed in writing.

Illumination on initials:

In Manuscript Writing accent is achieved by several familiar means.

The most common, perhaps, is by the use of enlarged initials. These can be embedded in the text or used entirely in the margin, as shown at the left, or with the stem trailed down the margin as with P on p. 31. Note that traditionally the line proceeds from the top rather than the bottom of the initial, which often is followed immediately by one or two words in capitals. As to the style of the initial, one may use the Versal (shown here and on p. 49 and so-called because it marked the beginning of the verse), the classic Roman or an enlarged capital of the text or similar letter. Enlarged lines at the beginning of a paragraph, as above, and color are often used. Bear in mind, however, that black is heavier than any color; and adjust the boldness of the letter accordingly. ¶ Principles governing the use of accent in any design apply as well to manuscript layout. Accents should have a certain consistency and there must not be too many of them. ¶ The importance of proper margins in manuscript writing cannot be overemphasized. (P. 25.) Legibility is promoted by lines of 4 to 8 words in length. ¶ Manuscript illumination is a subject too large to be dealt with adequately here. See the bibliography.

MANUSCRIPT WRITING. Two variations
from the normal spacing of lines. (See p.20.)

Packed or massed writing ∗ where space
is at a premium ∗ ∗ gives richness of
tone ∗ and requires bolder weight, shorter
ascending and descending stems ∗ lines of
equal length and no gaps between words.
Margins look larger ∗ the blacker the mass
of text appears ∗ Suited to long inscriptions

A more open style
is extravagant of space,
calls for wider margins,
longer stems and lighter weight,
and suggests elegance
& fineness of subject matter.
Suitable for short
quotations and lines of
unequal length.

CLASSIC ROMAN

BG DEI
FHJ
KQPTUV
WXYZ..

THE CLASSIC ROMAN alphabet on the preceding page is freely copied from the Trajan Column inscription and adapted for modern use with the pen or brush. We introduce it here to study further the basic, essential form of the Roman letters. Read again the discussion of proportions on p. 19. The outside of the O is a perfect circle. E is one-half the width of O. The top part of R, P and both parts of B are exactly the shape of D. ❡ The weight of the strokes is important. The height of the capital is about ten times the width of the thick stroke, slightly lighter than the written letter shown on p. 18. If made heavier, the letter loses its fine classic feeling. ❡ It is also important that thicks and thins be uniform in width. ❡ In contrast to preceding alphabets, this letter is drawn and pointed up rather than written. A pen approximating the width of the thin strokes (c) can be used on them and manipulated to make the serifs (d). Thick strokes are built up, blending slightly with the serifs. Large letters can be drawn conveniently by fastening two pencils together with rubber bands (ee). The forms then can be written functionally by keeping pencils at the 30° angle (f) except when making the left stroke of M, the vertical stems of N, the diagonal of Z and forward hooks of C, G & S, where manipulation is required. Draw serifs with one pencil.

If mechanically drawn, the serif is a segment of a circle. (a, a)

However, it is more beautiful if drawn freehand and blended slightly with the stem. —But avoid a wiggly appearance by not overdoing the softness of the lines.

Points and curves overlap the line a little to appear to be on it

Tails of R, K and Q should be drawn straight away and curved on the last third of the stroke.

Strong Weak
R Q R Q

Formal Italic

ABCDEFGHI
JKLMNOPQR
STUVWXY&Z

abcdefghijklm

S W A S H E S

nopqrstuvwxy

*Strokes may be extended with good
taste and respect for the basic form*

A C G E E F K L M M N
Z OOPQTUVXY

34

THE ITALIC differs from wide-pen Roman in four essential respects: 1. The Italic is condensed in form, the o being oval instead of round as in the Roman. All letters are the same width except i, j, l, m and w, and in the last two, the parts are equal in width to the o or n. This simplifies the problem of spacing, as shown in the exercise at the bottom of p. 37, the space within the letters approximating the space between the letters. 2. The Italic letter slopes at an angle of 5° to 10°. This slope should be consistent and should not be exaggerated. 3. The pen angle is increased to 45°. 4. Ascenders and descenders are somewhat longer in the Italic. Rule your master sheet 5-5-5 (penstroke units) instead of 4-5-3 as heretofore. ❧ These differences can only be mastered by conscious effort at first, but eventually one should be able to *think* Roman as vertical and round and Italic as sloped & condensed. Other features remain much the same, such as weight, height of the capitals (7-8 penstrokes), roundness of hooks and tails, use of bracketed serifs and the pulling of all strokes. ❧ Note at the right simplified forms of certain letters that are traditional with the Italic. Originally vertical Roman caps were used with this hand, but later they were sloped and sometimes flourished (swashes). When capitals are used alone, however, employ a simple form.

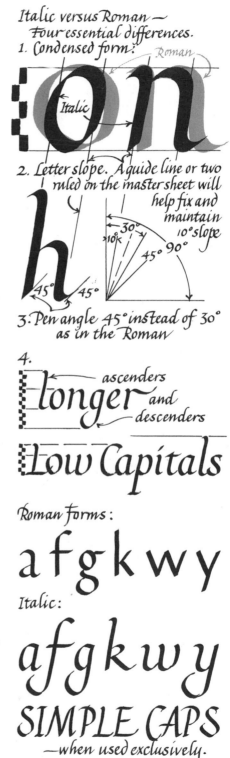

Italic versus Roman —
Four essential differences.
1. Condensed form:

Roman

Italic

on

2. Letter slope. A guide line or two ruled on the master sheet will help fix and maintain 10° slope

h

30°
10°
45° 90°
45° 45°

3. Pen angle 45° instead of 30° as in the Roman

4.

longer — ascenders and descenders

Low Capitals

Roman forms:

a f g k w y

Italic:

a f g k w y

SIMPLE CAPS
—when used exclusively.

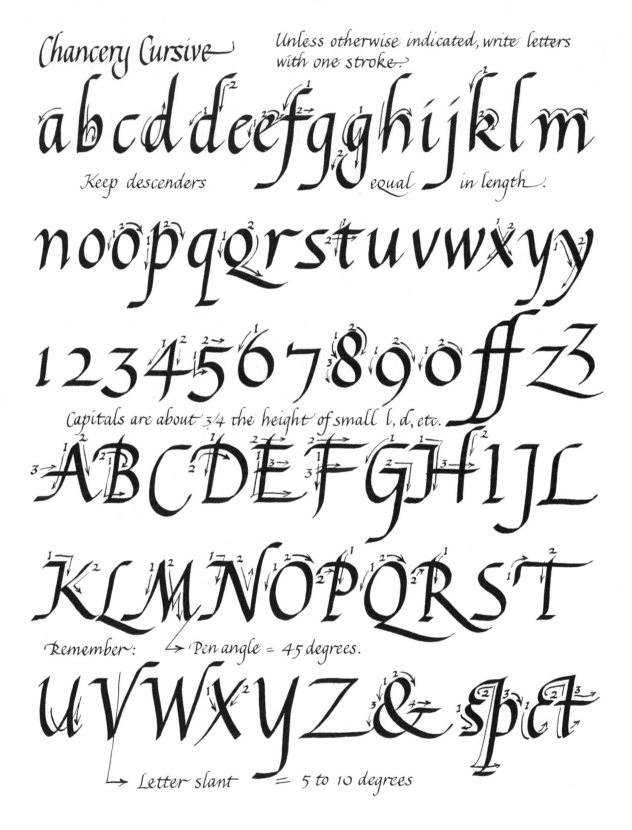

Chancery Cursive

Unless otherwise indicated, write letters with one stroke.

a b c d d e e f g g h i j k l m

Keep descenders equal in length.

n o o p q q r s t u v w x y y

1 2 3 4 5 6 7 8 9 0 ff Z

Capitals are about 3/4 the height of small l, d, etc.

A B C D E F G H I J L

K L M N O P Q R S T

Remember: Pen angle = 45 degrees.

U V W X Y Z & sp a

Letter slant = 5 to 10 degrees

36

CHANCERY CURSIVE found its name and its first popularity in the mid-sixteenth century, when it was adopted as the official hand for papal briefs. Ludovico Arrighi wrote the first handwriting manual on Chancery in 1522. On page 71 is a facsimile plate. Today's revival of this hand attests its usefulness & beauty. The Cursive is simply a rapidly written Italic, and will be individual to a degree with each penman. However, to be free and soundly creative demands long discipline & practice in the essential form. ❡ Unlike the formal Italic, in which all strokes are *pulled,* in the cursive the pen is pulled and pushed. Arrighi forms the body of the a, c, d & g in an oblong parallelogram as shown at the upper right. The pen will round the corners sufficiently. Though the Chancery is not a "current" hand, certain letters may be joined as specified on p. 40. Vertical proportions, condensed character, slope & pen angle are the same as for the formal Italic. ❡ Study Arrighi's original hand, checking the form of every letter. Try the basic strokes indicated in the margin. Then practice long and faithfully the exercises suggested on pp. 38–40. Write some every day. Write, write, write!!

"Formal Italic" versus "Cursive"

Basic Strokes:
Clockwise —

lead in

Counter clockwise —

Combinations —

For caps

According to Arrighi, all the small letters begin with one of two basic strokes:
1. Thick and moving in reverse,

as in abcdfghklogs

2. Thin and diagonal, as in

eijmnprtuvwxyz

Spacing Practice: Write an n or u chain exercise on your master sheet → Then write the alphabet sentence over it on the top sheet, as below:

a quick brown fox

Give and take space as necessary. This is only an exercise.
Your eye is always the final judge of spacing.

IT HAS BEEN ASSUMED that the student with a general interest in calligraphy will begin at the first of this book and proceed in sequence. However, this page is inserted here for those who choose to begin with the cursive to improve their handwriting, as well as for the very young just learning to write. It is inconsistent to teach children first a "print script" & then a current hand, some letters of which bear little resemblance to print. (See below.) We submit that the child learning Chancery from the beginning avoids this confusion & in the end possesses a beautiful as well as practical and legible hand.

A a E F F G Y I J M M N N S S

HERE then is the elementary Chancery Cursive Italic alphabet for beginners. (It would not hurt anyone to pause and study this essential form.) Use these letters in the following exercises with pencil & ballpoint pen until ready for the wide pen. Then return to p.36.

abcdefghijklmnopqrstu
vwxyz ABCDEFGHIJKL
MNOPQRSTUVWXYZ&

WARNING! If taking up Italic first and Roman subsequently, pay close attention to the pen angle, 45° for Italic, 30° for Roman. This is very important.

Right { For Italic, 45° pen angle
for Roman, 30° „ „

Wrong { Too heavy
Too light

REGARDLESS of the age of the scribe, time & work seem to be the important factors in acquiring a good hand. It follows that persevering practice pays off. The exercises below can be done with pencil or wide pen.

Good rhythm drills: 1. Clockwise, n chain.

2. Counter-clockwise, u chain.

n and u are the standard of letter width.
Write the other letters with them, so:

ana nan bnb nbn

— and so on through the alphabet.

Then with u:

cucucucududu

— Etc.

In Italic also, space between words = width of small o.

Don't let rapid writing get you into bad habits: Round the arches.

Not this — MINIMUM but this — minimum

Now, using the master sheet in the back of your book
for Osmiroid "Broad" pen, write an alphabet sentence over and over. (This is reduced 1/3.)

a quick brown fox jumps over the lazy dog a qui

Keep ascenders — and descenders

ck brown fox jumps over the lazy dog pack my

equal in length

bag with five dozen jugs of liquid veneer pack m

excepting t, f & o.

EXERCISES CONTINUED — CAPITALS

Again using the 1/8" pen, practice the Capitals through the alphabet in names, so:

Rule lines at first to check slant

Able Baker Charlie

Capitals are of lower height to make less accent

←10°

Duke Eve Frank Gi

ll Harriet Isabelle

Etc. again & again.

Then with the
Osmiroid "Broad" pen: Active Atomic Ash Better Baked

Beans Canned Codfish Custard Double Duty Doe

Etc.

If you have trouble with
one letter such as k or p,
practice it in a word: Kinnikinnik Pepper Kinnikinni

Etc.

Certain letters can be joined
with those following: am du er in kr lo me na up

—Others sometimes: ct fi sp st st te oo However,

whether to join or not to join is optional......

Now, using a "medium" or "fine" nib, as you prefer, write a letter or
address a lot of Christmas cards. Speed up gradually & rhythmically.

CHANCERY CURSIVE as written by sixth-graders

A Nation's Strength

①

Not gold, but only man can make
 A people great and strong;
Men who, for truth and honor's sake,
 Stand fast and suffer long.

Brave men who work while others sleep,
 Who dare while others fly—
They build a nation's pillars deep
 And lift them to the sky.

The Galway Piper

④

Ev'ry person in the nation,
Or of great or humble station,
Holds in highest estimation
Piping Tim of Galway.

②

On my honor I will do my best—
 To do my duty to God and my country,
 and to obey the Scout law;
 To help other people at all times;
 To keep myself physically strong, men=
 tally awake, and morally straight.

③

A bird came down the walk:
He did not know I saw;
He bit an angle-worm in halves
and ate the fellow, raw.

⑤

When the wedding bells are ringing,
 His the breath to lead the singing,
 Then in jigs the folks go swinging,
 What a splendid piper!

1. Charlotte Bardeen. 2. S. Frazo, Age 11. 3. Robert McCombs, Age 12. 4. Peggy Patrick, (Left=handed). 5. Christine Hayward. Pupils of Fred Eager, Caledonia, New York. Reproduced actual size.

CHANCERY CURSIVE as written informally by professionals

Dear Ralph :
①

Of course

use my writing in any way

With thanks & all good wishes for 1966.

Yours sincerely

Alfred Fairbank

for who deserve only the best

for their working models.

Sincerely

Alfred P. Maurice

Yours sincerely

Paul Standard

Many thanks again.

Yours, ②

Lloyd

21·iij·1966

best wishes to you & to Miriam.

Yours,

Arnold Bank

All Good Wishes for the New Year

Sincerely

Heather Child.

recent trip to Scotland. I hope to go there, m'sel'

Cordially

Theodor Jung

and to meet Tom Gourdie at Kirkaldy.

Hoot, Mon ! Cordially.

③

Ray.

1. James Hayes. 2. Lloyd Reynolds. 3. Raymond DaBoll. Note the highly personal character of each hand.

42

A Pointed Italic · with characteristics
of Chancery and Black Letter · See pp. 46-48.
a Batarde style

a b y d e f g

h i j k p g l m c n o r s t u v

w x z A B C D E

E F G H H I J K M

L N O P P Q R R S

T U V W X Y Z Study the
Chaucer ms. p. 69
before using this.

English Roundhand ~ known

Ascenders — Space between lines ~ 9/8" Capitals

also as Copperplate — 3/8" Small letters

9/16" Descenders

9/16" Ascenders

a "current" hand ~ unm nan an

Extreme slant 30° to 40° but consistent

a nbn uau etc. Aa Bb Cc Dd Ee

Ffff Gg Hh Hh Ii Jj Kk L

Ll Ll Mm Mm Nn Oo Ppp P

Qu Qg Rr Rr S Sss Tt UuVv

Ww Ww Xx Yy Zz 1234567890

ENGLISH ROUNDHAND or Copperplate is the perfect example of a letter form dictated by the tool with which it is made, following a principle enunciated repeatedly in this book. A graver used on a copper plate makes the free-flowing curves of Roundhand quite naturally; hence its long popularity in formal engraved announcements. It is also a "natural" for the flexible, pointed pen which we use here. ❡ Unlike preceding alphabets created by the wide pen, the thicks and thins of Roundhand are the result of varied pressure. A heavy hand can only be applied while the pen is drawn straight away; to push the pen or move it sidewise under pressure may produce a splatter and break it. Therefore, in order to accomodate the extreme letter slant, an "elbow" pen staff is used by the right handed person (not required for the "southpaw"). Note suggestions at the right on pen and board position. ❡ This formal, calligraphic, current hand is not the rapid, commercial, secretarial longhand described in some penmanship manuals and executed entirely by arm movement. It is rather more deliberately drawn by a combined arm-wrist-finger manipulation, with a relaxed freedom to be sure, but not too swiftly. ❡ Practice the small letters in the chain exercises with u and n and in alphabet sentences. Write the capitals & small letters together in proper names.

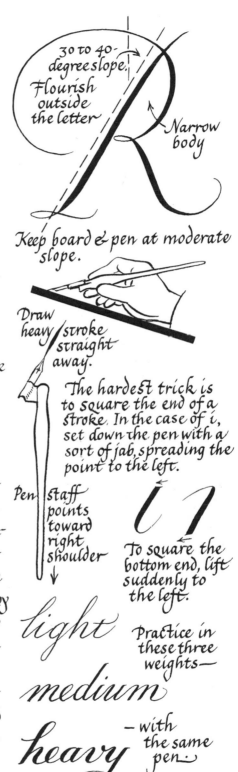

30 to 40-degree slope. Flourish outside the letter

Narrow body

Keep board & pen at moderate slope.

Draw heavy stroke straight away.

The hardest trick is to square the end of a stroke. In the case of i, set down the pen with a sort of jab, spreading the point to the left.

Pen staff points toward right shoulder

To square the bottom end, lift suddenly to the left.

light

medium

heavy

Practice in these three weights—

—with the same pen.

black letter

abcdefghij

klmnopqr

stuvwxyz

BLACK LETTER, so called because of its condensed character, is the product of the Gothic period and in its extreme verticality is kindred to the architecture of that time. Just as the classic Roman is essentially round, this style of lettering is tall and narrow in the small letters, like a Gothic arch. ❧Black Letter is more decorative than legible. Associated as it is with cathedrals and sacred writings, it retains an ecclesiastical connotation. Simple black letter caps, created functionally with a wide pen, are shown on p. 42. A slightly wider pen may be used on the wide and open capitals, especially when in color, to give them the same weight as the condensed small letters. Decorative Lombardic capitals (p. 49) are also used with small black letters. ❧The stroke employed in writing this hand goes abruptly from thick to thin, most thick strokes taking the form of a black parallelogram. Rule your guide lines as before (p. 20) with spaces of 4, 5 and 3 pen-widths. Then place your strokes so that guide lines b and c go through the extreme corners of your black parallelograms. Thus, the letters are easily formed. To space them, leave about 1½ pen widths between vertical strokes, whether the space be within or between the letters (see "bowing,") except with c, e, f, r, x and z, when the eye becomes the judge of spacing.

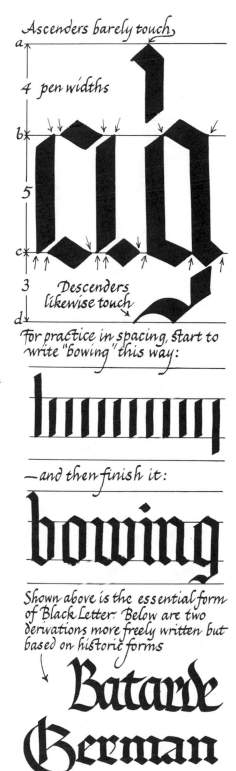

Ascenders barely touch,

a

4 pen widths

b

5

c

3

Descenders likewise touch

d

For practice in spacing, start to write "bowing" this way:

—and then finish it:

bowing

Shown above is the essential form of Black Letter. Below are two derivations more freely written but based on historic forms

Batarde

German

Black Letter

F G
A B
C D
E H I J K M
L N O P Q R
S T U V W X
Y Z · Capitals

VERSAL LETTERS Gg Ym

D Ø O P R E Q Ym

Devise the other letters from Roman forms in a similar manner. See p. 58.

See p. 58.

LOMBARDIC ✠ ✠
CAPITALS ✠ FGH
JKMNQVWXYZ

Detail from an Italian fourteenth-century antiphonary. Original in the possession of the Walters Art Gallery, Baltimore. Used by permission.

Spanish Round Gothic

Pen widths

3½

aabcdddefghi

3½

Ascenders and descenders meet half-way

jklmnopqrsss

tuvvwxyz;?!crt

fs ti œ œ · m A

BCDEFGH

JJKLMNOP;

QRSTUVWX

YZ

Baroque initials
from an old Ms.

Pas

Salutis

50

SPANISH ROUND GOTHIC, similar to "ROTUNDA", is apparently a Southern European relative of Black Letter. It is found in colonial manuscripts of the American Southwest in the same form used in Spain at that time. ¶ Round Gothic should interest the contemporary calligrapher because it is more legible than Black Letter, while retaining much the same ecclesiastical connotation. Its simplicity in the small letters contributes to legibility, as does also its variety of form and stroke. Round Gothic is the first hand introduced in this book which calls for a manipulation of the pen from the horizontal, or "flat" position + to the diagonal position ✗ used in preceding alphabets. As shown at the top right, some letters such as i and l are created from the "flat" position; o, c, s, etc. from the diagonal position; while in writing b, p, n, etc. both positions are used. By this adjustment of pen angle to the direction of stroke, the page takes on a remarkably even tone when well spaced. When "freezing" curved letters together, avoid a black spot by overlapping strokes completely. ¶ In the capitals, the same claim to legibility can hardly be made. Perhaps for this reason many scribes used classic Roman or Lombardic uncials for initial letters. Some old mss. show an illuminated Roman capital & a Baroque initial on the same page.

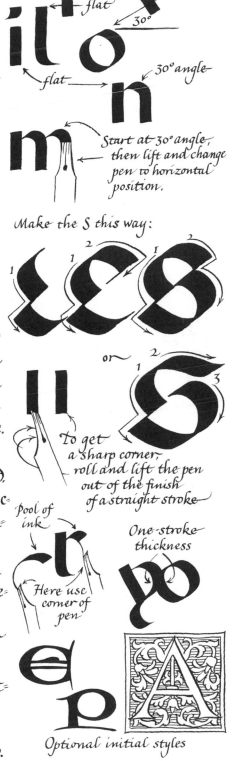

flat

30°

flat

30° angle

Start at 30° angle, then lift and change pen to horizontal position.

Make the S this way:

or

To get a sharp corner, roll and lift the pen out of the finish of a straight stroke

Pool of ink

Here use corner of pen

One-stroke thickness

Optional initial styles

RVSTIC+ANEARLY
WRITTENROMAN
+ABCDEFGHIJRL
NOPQTVVXYZ

IRISH OR IHSULAR

halfuhcial+bde

gmnpqſſuuwxyz

52

TOOLS FOR BRUSH LETTERING

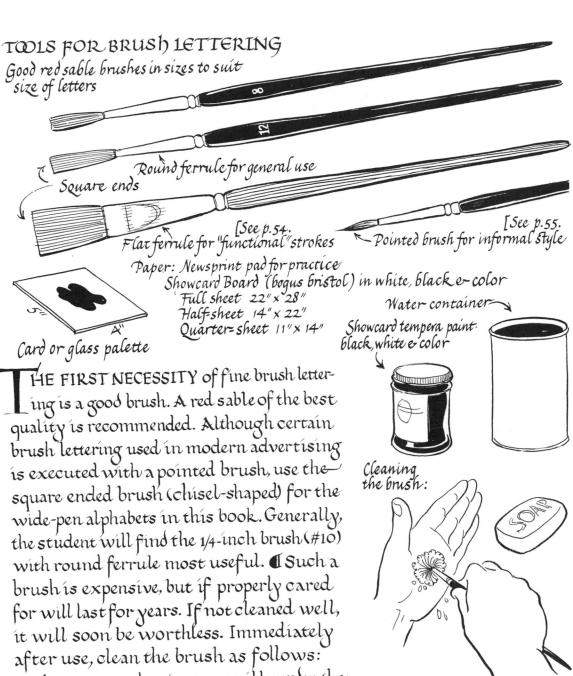

Good red sable brushes in sizes to suit size of letters

8

12

Square ends

Round ferrule for general use

Flat ferrule for "functional" strokes

[See p.54.

Pointed brush for informal style

[See p.55.

Paper: Newsprint pad for practice
Showcard Board (bogus bristol) in white, black & color
Full sheet 22" x 28"
Half-sheet 14" x 22"
Quarter-sheet 11" x 14"

Card or glass palette

5"

4"

Water container

Showcard tempera paint:
black, white & color

Cleaning
the brush:

SOAP

Leave the brush
in this form to dry

THE FIRST NECESSITY of fine brush letter-ing is a good brush. A red sable of the best quality is recommended. Although certain brush lettering used in modern advertising is executed with a pointed brush, use the square ended brush (chisel-shaped) for the wide-pen alphabets in this book. Generally, the student will find the 1/4-inch brush (#10) with round ferrule most useful. ❡ Such a brush is expensive, but if properly cared for will last for years. If not cleaned well, it will soon be worthless. Immediately after use, clean the brush as follows: Wash out as much paint as possible under the faucet. Then, clean thoroughly with mild soap, boring the brush into the palm of the hand so as to spread the hair. Rinse. Repeat this until absolutely no pigment shows.

Stroking the brush—trademark up

Too wet Too dry Just right

Use left hand to place brush in the right—then hold it vertically.

Occasionally dip the brush in water to prevent pigment drying here

TREAT A GOOD BRUSH as if it had personality and it will respond accordingly! First, work the paint into it thoroughly by stroking for a minute or two on the palette. The paint must be mixed to just the right consistency, thin enough to make a solid stroke, thick enough to hold the brush at a sharp chisel edge of normal width. ¶ There are two kinds of brush strokes to be mastered. The first, which we arbitrarily call "functional", is the result of holding the brush at a fixed angle and letting it create the letters in thick & thin strokes, as does the pen in most of the preceding alphabets. Here it is even more important with brush than with pen to glide into the stroke and out as a plane lands and takes off. The second kind of stroke, which we call "manipulated", is peculiar to the brush, which is twirled between thumb and forefinger while the hand is in motion, resulting in a stroke uniform in width with no thicks or thins.

FUNCTIONAL STROKES· Practice these and then try them on wide-pen Roman and Italic alphabets.

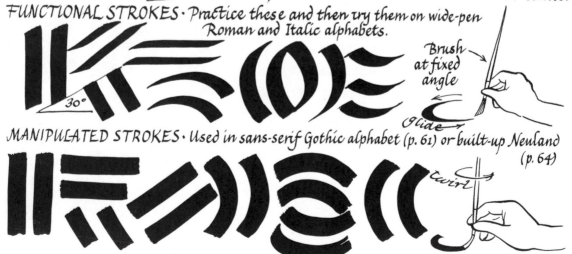

30°

Brush at fixed angle

Glide

MANIPULATED STROKES· Used in sans-serif Gothic alphabet (p. 61) or built-up Neuland (p. 64)

twirl

BRUSH LETTERING is the natural medium of the poster. The principles of layout, outlined on p. 25, will be useful here. It is well to list the various items of the copy in an order of emphasis and determine their position, size, color or weight in the design accordingly. However, these & other attention-getting devices or forms of variety must not be overdone, lest the design disintegrate or become spotty. For this reason, limit sizes, colors and styles of lettering to two each or at most three. ¶ Striping can be used effectively in a poster. Hold a ruler as shown at the right and let the ferrule of the brush slide along its edge. ¶ Although the scope of this book is concerned primarily with calligraphic writing with the wide pen and wide brush, the student should be made aware of other calligraphic means,—hence, the introduction of Roundhand with the pressure pen on p. 44, and here, mention in passing of the pointed brush and its characteristic forms. In contemporary painting there is considerable interest in the "calligraphic", concerned with freely moving lines & the spaces they enclose. A very popular form of brush lettering used today in advertising is based on the same principles, using a pointed brush, placing accents and spaces as they are felt but always respecting the essential form of the letters.

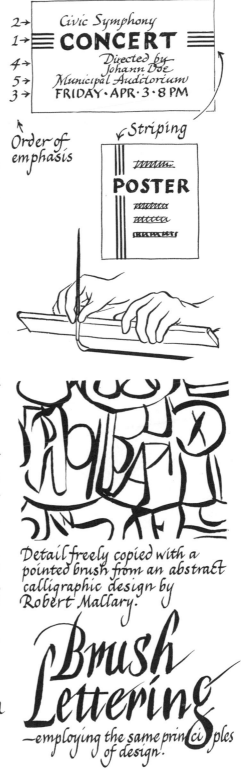

Order of emphasis

Striping

Detail freely copied with a pointed brush from an abstract calligraphic design by Robert Mallary.

Brush Lettering
—employing the same principles of design.

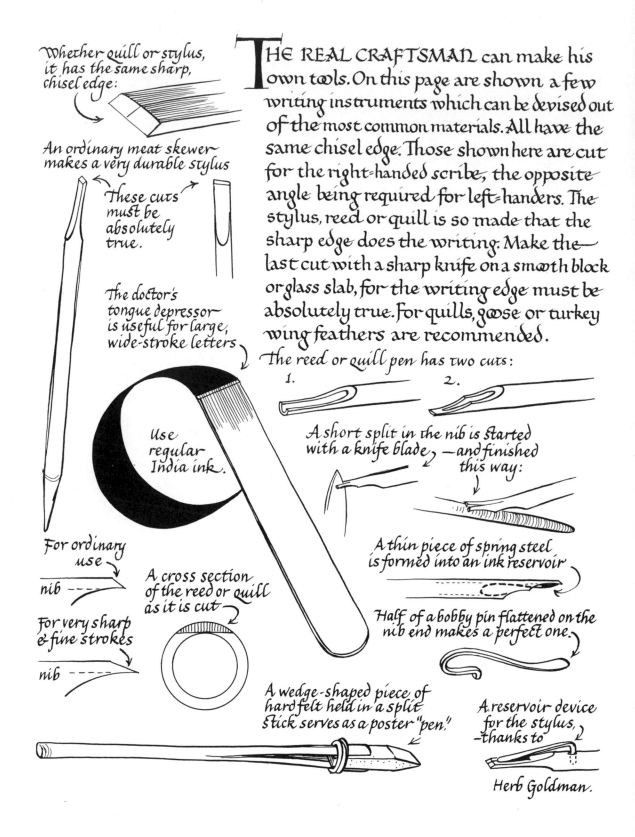

Whether quill or stylus, it has the same sharp, chisel edge:

THE REAL CRAFTSMAN can make his own tools. On this page are shown a few writing instruments which can be devised out of the most common materials. All have the same chisel edge. Those shown here are cut for the right-handed scribe, the opposite angle being required for left-handers. The stylus, reed or quill is so made that the sharp edge does the writing. Make the last cut with a sharp knife on a smooth block or glass slab, for the writing edge must be absolutely true. For quills, goose or turkey wing feathers are recommended.

An ordinary meat skewer makes a very durable stylus

These cuts must be absolutely true.

The doctor's tongue depressor is useful for large, wide-stroke letters

Use regular India ink.

The reed or quill pen has two cuts:

1.

2.

A short split in the nib is started with a knife blade —and finished this way:

A thin piece of spring steel is formed into an ink reservoir

A cross section of the reed or quill as it is cut

For ordinary use
nib ---

For very sharp & fine strokes
nib ---

Half of a bobby pin flattened on the nib end makes a perfect one.

A wedge-shaped piece of hard felt held in a split stick serves as a poster "pen."

A reservoir device for the stylus, —thanks to

Herb Goldman.

56

a John Doe

b John Doe

c John Doe

← *Showing what happens when the pen angle is varied* →

THE ROOT meaning of "calligraphy," which derives from the Greek, is "beautiful writing." In creative calligraphy, then, the penman's first obligation is to make what he is doing handsome. So far in this book, attention has been directed to the basic form of the letter. As you continue to practice, you will develop your own characteristic, individual hand. See that your interpretation is both legible (respecting the basic form) and beautiful. You can do this by returning again and again to a study of fine originals, and by applying the principles of design to details of your writing, such as stroke endings and the placement of accents. Above is shown one method of giving variety to the written letter; and on the following pages, other ways of improving the form by drawing.

Study counters, joins, curves and tails.

Make the accidents serve you.

J e

J.D.

Begin with the written form and develop it.

1. "Write" a line of letters, using the most simple form of the Roman alphabet.

Letter

2. Write the same line again and retouch, or "point it up", with a fine pen.

Letter

3. Now, using only the fine pen, "draw" the letters from the beginning, trying to improve further the design, and add thin serifs.

One way

Letter

One way serifs:

MN

bdhl

No serif

mnr

Odd
fellows

ü ipA

Vertical serifs:

c's z CSE

To get stem widths uniform, DON'T outline first and then fill in —the widths of the outlines will fool you. Rather, start with a pool of ink and work out →

LETTERS are created in two ways: by writing them and by drawing or designing them. Most of the alphabets studied up to this point are written or "calligraphic", the form being dictated functionally by the pen. Versals, Lombardics & the type faces that follow are examples of designed letters. Both of these approaches influence all creative lettering more or less just as both emotion and intelligence bear on all creative design. ¶ On this page is suggested an exercise (not original with the author) in "drawing" letters, giving the artist opportunity to improve their design creatively without violating the essential form. Read the directions at the left carefully and experiment step by step. This requires time and care. ¶ Note the relation between the Step-3 letter and the Versal (p.49). Versals are a little less severe, stems being flared slightly toward the serifs. Bernhard Modern type (p.63) has the spirit of the Versal. Note the warnings below on how to build up stems to proper width & how to draw beautiful bows. This exercise also furnishes a timely opportunity to study the traditional direction of the serif on various letters.

Exception: With Versals & Lombardics, outline the letter—

I O O B B

—drawing the inside first.

IN LETTERING FOR REPRODUCTION, the emphasis shifts from the original art to the printed copy of it. It is possible for a beautiful original to be very disappointing when reproduced. The artist must understand enough of the processes of photoengraving & printing so that his work can run the gamut of photography, etching, paper, ink & printing, and look as well in the end as in the beginning. ⁋ To design a short title or firm signature for reproduction, one takes time to draw the letters carefully, designing and retouching the written form. Often letters from a good type alphabet, such as one of those found on the following pages, are freely copied or adapted. The artist's creativeness finds its expression in the aptness of the letter style selected and its spacing, as well as in the limited designing of single letters to suit their use. In reproducing an alphabet such as Futura Medium (p. 61) precision is promoted by the use of mechanical tools (c). However, to avoid a rigid or stiff effect and to perfect the spacing, it is important to sketch in pencil freely (a, b) before applying the ruling pen. Of course, letters with soft lines must be done freehand. ⁋ The work is finished by retouching where necessary with pen & ink and white tempera. Then a flap of bond paper is hinged over the plate to prevent soiling.

For large finished work to be reproduced, use smooth bristol board of good quality. First, sketch a line of letters freely in pencil:

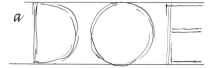

a

Then more carefully, but still freehand:

b

Then apply mechanical tools if the letter permits, inking over the pencil layout:

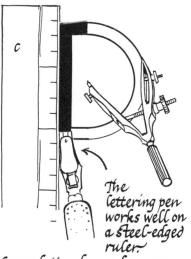

c

The lettering pen works well on a steel-edged ruler.

Some letter forms, however precise, must be done freehand:

White tempera, applied over the black ink, sharpens the corners. Use waterproof ink only.

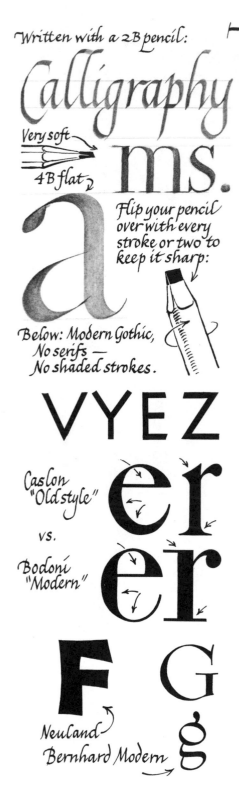

Written with a 2B pencil:

Calligraphy

Very soft →

4B flat →

ms.

Flip your pencil over with every stroke or two to keep it sharp:

a

Below: Modern Gothic, No serifs — No shaded strokes.

VYEZ

Caslon "Old style"

er

vs.

Bodoni "Modern"

er

F

Neuland

G

g

Bernhard Modern

TYPE FACES are not often strictly calligraphic, and therefore have no place in such a text as this except in their relationship to written forms and in their exemplification of lettering design principles. Whatever the style of type, it can be rendered calligraphically with a soft pencil as shown at the left. Sharpen the pencil to a chisel edge on fine sandpaper and keep it sharp. The wider the pencil, the softer and sharper it must be to make a black mark. Pencil rendering is good practice for the calligrapher and a valuable skill for the layout man. ¶ The following exemplar types were selected each for a special purpose. Futura Medium is a modern sans-serif Gothic proportioned after the classic Roman, a sound idea followed by several contemporary designers with distinction. Caslon & Bodoni, every printer's old "stand-bys," were designed at about the same time but have entirely different feeling. Both are Roman derivatives. Garamond Italic, another standard, illustrates with simple elegance what an artist typographer can do with the sloped letter. Bernhard Modern embodies much of the fine, dignified style of the Versal. Although modern, it reminds us that we can still be humane. Neuland is included as another example of letter form dictated by its medium. With its sharp corners, it is obviously a cut-out. It makes a good poster letter.

FUTURA MEDIUM · A Modern Sans-serif Gothic Type.

ABCDEFGHIJ

KLMNOPQRS

TUVWXYZ&?

abcdefghijklm

nopqrstuvwxyz

1234567890

CASLON (540)

ABCDEFGHIJ
KLMNOPQRS
TUVWXYZ &
abcdefghijklmn
opqrstuvwxyz

BODONI

ABCDEFGHIJKLMN
OPQRSTUVWXYZ&
abcdefghijklmnopqrs
tuvwxyz 1234567890

GARAMOND ITALIC

ABCDEFGHIJKLMNO
PQRSTUVWXYZ
abcdefghijklmnopqrstuvwxyz
A B C D E G L M P &
1234567890$&

BERNHARD MODERN

ABCDEFGHIJKLMN
OPQRSTUVWXYZ&
abcdefghijklmnopqrst
uvwxyz 1234567890

FUTURA DISPLAY

ABCDEFGHIJKLMNO

PQRSTUVWXYZ&()

$1234567890

abcdefghijklmnop

qrstuvwxyz fi ff ft fl

NEULAND

ABCDEFGHIJ

KLMNOPQR

STUVWXYZ

1234567890

BIBLIOGRAPHY

Arrighi, Tagliente and Palatino, *Three Classics of Italian Calligraphy*, Introduction by Oscar Ogg, Dover Publications, Inc., New York, 1953 [1951

Bank, Arnold, *Arnold Bank Lettering Portfolio*, privately printed, Portland, Oregon,

Benson, J.H. and Carey, A.G., *Elements of Lettering*, 2nd Edition, McGraw-Hill, New York, 1950

Benson, John Howard, *The First Writing Book, An English Translation and Facsimile of Arrighi's "Operina"*, Yale University Press, 1955

Burgoyne, Philip A., *Cursive Handwriting*, Dryad Press, Leicester, England, 1955

Chappell, Warren, *Anatomy of Lettering*, George McLeod, Ltd., Toronto, 1935

Fairbank, Alfred J., *A Manual of Handwriting*, Transatlantic Arts, Inc., Hollywood-by-the-Sea, Florida, 1955

Fairbank, Alfred J., *The Dryad Writing Cards*, The Dryad Press, Leicester, 1935

Fairbank, Alfred J., *A Book of Scripts*, Penguin Books, Baltimore, Maryland, 1960

Fairbank, Alfred J. and Berthold Wolpe, *Renaissance Handwriting*, The World Publishing Company, Cleveland and New York, 1960

Fisher, Reginald, *The Way of the Cross, A New Mexico Version*, School of American Research Publication, Santa Fe, 1958. Hand-written by Ralph Douglass.

Goudy, F.W., *The Alphabet and Elements of Lettering*, University of California Press, Berkeley and Los Angeles, 1942

Gourdie, Tom, *Italic Handwriting*, Studio Publications, London, 1955

Harrison, Frederick, *English Manuscripts of the Fourteenth Century*, Studio Publications, Inc., New York, 1937

Holub, Rand, *Applied Lettering and Design*, Watson-Guptill Publications, New York, 1949 [New York, 1954

Hornung, Clarence Pearson, *Lettering from A to Z*, Tudor Publishing Co.,

Johnston, Edward, *Writing and Illuminating and Lettering*, Pitman Press, Bath, 1945. (Reprint of 1906 ed., originally published by John Hogg) An excellent and complete reference for any calligrapher.

Johnston, Edward, *Manuscript and Inscription Letters*, With 5 plates by A. E. R. Gill, Pitman & Sons, London, 1946. (Reprint of 1911 Revised Ed.)

Ogg, Oscar, *An Alphabet Source Book*, Harper & Bros., New York, 1940

Ogg, Oscar, *The 26 Letters*, Thomas Y. Crowell Company, New York, 1948

Reynolds, Lloyd J., *Italic Lettering and Handwriting Exercise Book*, Revised Edition, Champoeg Press, Portland, Oregon, 1957

Reynolds, Lloyd J., "*Italic Writing and Lettering,*" Art Education in Oregon Elementary Schools, State Department of Education, Salem, Oregon, 1958

Standard, Paul, *Calligraphy's Flowering, Decay and Restauration, with Hints for its Wider Use Today*, The Society of Typographic Arts, Chicago, 1947

Thompson, Tommy, *How to Render Roman Letter Forms*, American Studio Books, New York, 1946

Thompson, Tommy, *The Script Letter*, Studio Publications, New York, 1949

SOME MORE RECENT publications on Calligraphy ~ 1967

Child, Heather, *Calligraphy Today*, Studio Books, London, 1963. American Distributors: Watson-Guptill Publications, New York and Cincinnati.

Da Boll, Irene Briggs, *Recollections of the Lyceum & Chautauqua Circuits*, Presented in Calligraphic Format by Raymond F. DaBoll. The Bond Wheelwright Company, Freeport, Maine, 1967.

Eager, Fred, *Guide to Italic Handwriting with Capitals by George Miller*, Italimuse, Inc., Caledonia, N. Y., 1963.

Eager, Fred, *Write Italic!* Books I, II & III. Italimuse, Inc., Caledonia, N.Y., 1965.

Fairbank, Hooper and Stone, *Beacon Writing Books*, Reed College Co-op, Portland, Oregon, 1958-9. New inexpensive copy books designed for school children and teachers.

Filby, P. W. (compiler), *Calligraphy & Handwriting in America*, Italimuse, Inc., Caledonia, N. Y., 1963.

Filby, P. W., *2000 Years of Calligraphy*, The Walters Art Gallery, Baltimore, Md., 1965.

Gourdie, Tom, *The Puffin Book of Lettering*, Puffin-Penguin Books, Inc., Baltimore, Md., 1961.

Lindgren, Eric, *ABC of Lettering and Printing Types*, Volumes A, B and C. Museum Books, Inc., N. Y., 1964-66.

Reynolds, Lloyd J., *Calligraphy: The Golden Age and its Modern Revival*, Portland Art Museum, Portland, Oregon, 1958.

Ullman, B. L., *Ancient Writing and its Influence*, Cooper Square Publishers, Inc., N. Y., 1963.

Zapf, Hermann, *Typographic Variations*, Limited edition. Museum Books, Inc., N.Y., 1964.

PLATES

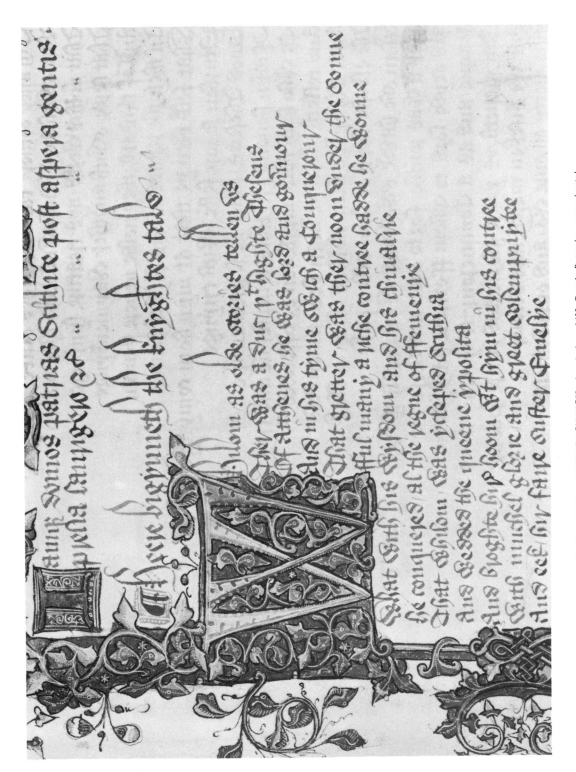

Detail from the Knight's Tale, ELLESMERE CHAUCER, dated about 1400. Text in Batarde, approximately original size. Used by permission of the Huntington Library, San Marino, California.

Written on vellum with a crow quill before the days of eye glasses! Reproduced actual size from a Dominican "Portable Bible" of the thirteenth century. The original shows hairline stroke finishes.

70

Farai dal primo tracto grosso & pia=
no questo corpo o ˜ r o dal
quale' ne' caui poi cinque' littere'
a d c g g
Dele' quali lr̃e' tutti li corpi che' toca=
no la linea, sopra
la quale' tu scri
uerai,
se' hanno
da
formare'
in
vno quadreto oblongo
et
non quadro perfet to, in tal modo
cioe' ☐ ·· r̃ o· a· o· c· d g ·· g ☐
a d c g g

Section from a License of Alienation (permission to sell hereditary lands) granted by Queen Elizabeth of England in 1585. Reproduced nearly actual size, from the original hand-written parchment in the Korber Collection, University of New Mexico Library, Albuquerque.

72

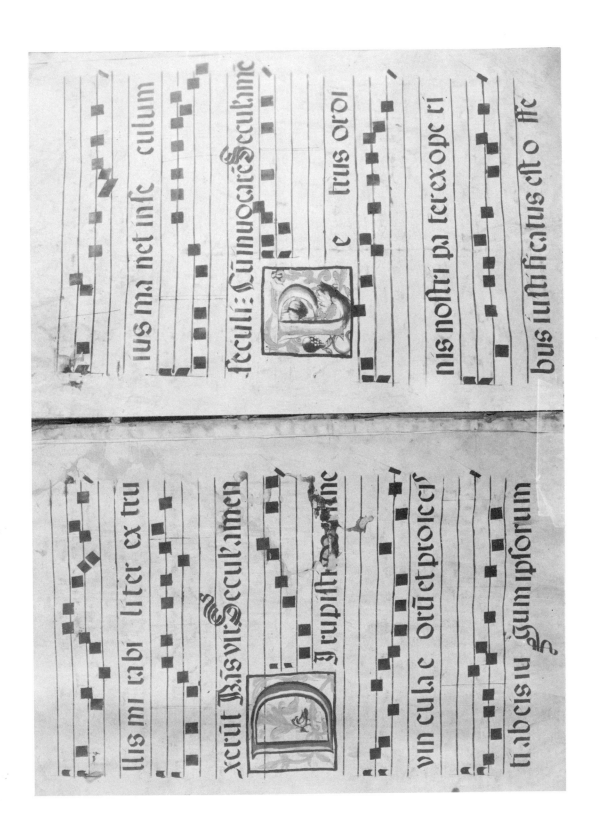

Double page from a Spanish Colonial Choir Book dating from the XVII century. Single page is 33 inches high by 22 inches wide. Staff lines in red. From the Morley Collection of Ecclesiastical Art, School of American Research, Museum of New Mexico, Santa Fe.

that went to the battle were Eliab the first-
born, and next unto him Abinadab, and the
third Shammah. And David was the young-
est: and the three eldest followed Saul. Now
David went to and fro from Saul to feed his
father's sheep at Beth-lehem. And the Philis-
tine drew near morning and evening, and
presented himself forty days. ——⟡——⟡

AND JESSE SAID UNTO DAVID

HIS SON, Take now for thy brethren an

ephah of this parched corn, and these ten
loaves, and carry them quickly to the camp
to thy brethren; and bring these ten cheeses
unto the captain of their thousand, and
look how thy brethren fare, and take their

12

Page 12 from ''The House of David his Inheritance. A Book of Sample Scripts.'' Victoria and Albert
Museum, London. Crown Copyright. Edward Johnston, 1914.

22 March 1966

Dear Mr. Douglass,

Thank you for your kind letter. Yes, we must certainly hope "the best is yet to be", but I cannot now write as I did before the war.

You may, of course, reproduce the last part of my letter dated 30.12.1965, & use the letter for promotion purposes. Why not use the letter for one of your plates? It represents a septuagenarian's free hand. You mention the sonnet in Plate 40 of my manual, but I haven't written such pieces since 1939.

All good wishes.

Yours sincerely
Alfred Fairbank

A dean of the profession and pioneer in the field of teaching italic handwriting writes informally, showing how a thoroughly disciplined and knowledgeable hand, acquired early, lasts. Reproduced actual size. Alfred Fairbank, England. 1966.

DAILY PRAYER
OF A
PHYSICIAN

ALMIGHTY GOD,
Thou hast endowed MAN
with the wisdom to relieve the suffering of his
brother, to recognise his disorders, to extract
the healing substances, to discover their
powers and to prepare and to apply them to
suit every ill. In Thine Eternal Providence
Thou hast chosen me to watch over the life
and health of Thy creatures.

Inspire me with love for my art and for Thy
creatures. Do not allow thirst for profit,
ambition for renown and admiration, to inter-
fere with my profession, for these are the
enemies of truth and of love for mankind and
they can lead astray in the great task of
attending to the welfare of Thy creatures.
Preserve the strength of my body and of my
soul, that they ever be ready to help and support
rich and poor, good and bad, enemy as well as
friend. In the sufferer let me see only the hum-
an being. Let me never be absent-minded.
May no strange thoughts divert my attention
at the bedside of the sick, or disturb my mind
in its silent labors, for great and sacred are the
thoughtful deliberations required to preserve
the lives and health of Thy creatures.
Grant that my patients have confidence in
me and my art and follow my directions and
my counsel.

Prayer. Decorative top line in 12th century Spanish. Text written with a split pen and colored with a pointed brush. 15¼″ x 30½″. Used by permission of the artist and Portland Art Museum. Arnold Bank. 1956.

77

Decorative Alphabet, illustrative of the point made on page 55. Black ink and brush. 15¾'' x 20''.
Used by permission of the artist and Portland Art Museum. Arnold Bank. 1958.

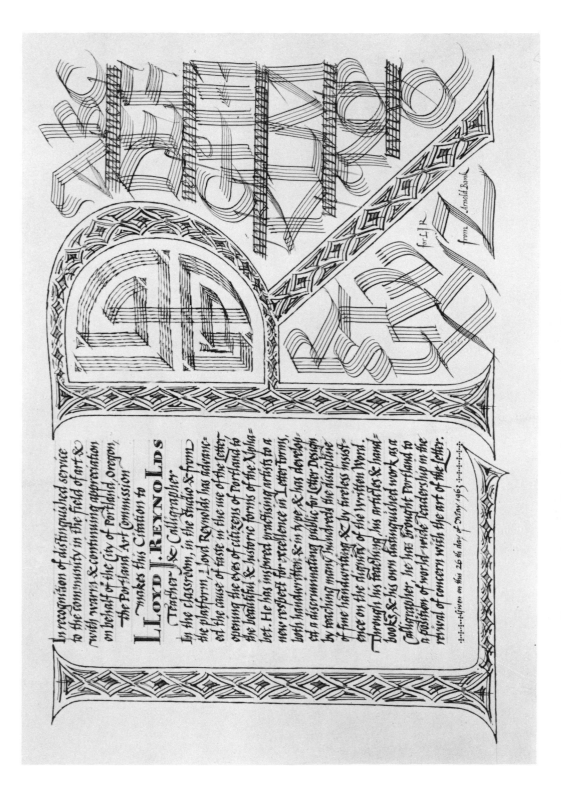

One great teacher and calligrapher salutes another. Original 19¾″ x 13⅝″ on parchment. Lettering in black with red and blue accents on large Roman initials, guide lines red. Used by permission. Arnold Bank. 1963.

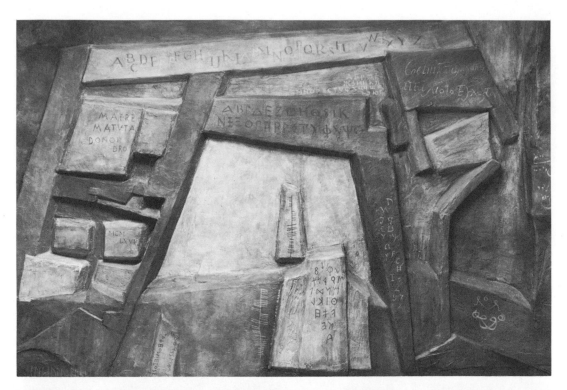

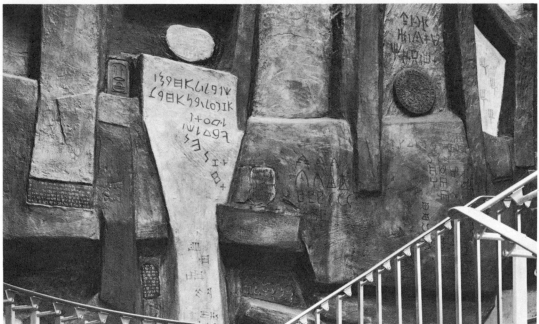

The History of Writing. Details from a contemporary sculptured mural presenting man's efforts at written communication from cave wall scratches to the Latin (Roman) alphabet. In the University of New Mexico Zimmerman Library, Albuquerque. Used by permission of the artist and the University. John Tatschl. 1966.

To the Glory of God + + + and the Honored Memory of the Sons of This Church Who Gave Their Lives in World War II - 1941-45 + This Tower Is Reverently Dedicated

Corporal	FARLEY ABSHIRE
Lieutenant	WILLIAM M. AGNEW, JR.
Lieutenant Colonel	CLARENCE M. BOTTS, JR.
Seaman First Class	HUGH ALBERT COOPER, II
Private	DONALD RALPH DOUGLASS
Ensign	FRANK EUGENE FURBY
Lieutenant	HARRY D. GILES
Lieutenant	ROBERT H. GREENWELL
Major	FRANK GRIMMER
Private	DAVID EDGAR GRUBBS
Lieutenant	ARTHUR WILLIAM McCORMICK, JR.
Staff Sergeant	WILLIAM HOWARD MEYER
Sergeant	WILLIAM FOSTER MURPHY
Lieutenant	FREDERICK McCREARY SCHNEIDER
Major	MONTE STRONG
Lieutenant Junior Grade	JAMES W. SYME
Major	THOMAS WILKERSON, JR.
Private	NORMAN E. WILLIAMS
Lieutenant	FRED E. WILSON, JR.

War Memorial, First United Presbyterian Church, Albuquerque. Photo-engraved on dull brass, letters filled with black. Framed in carved oak. 9½″ x 15″. Used by permission. Ralph Douglass. 1955.

he hath shewed thee
O man, what is good;
and what doth The Lord
require of thee, but to do justly,
and to love mercy, and to walk
humbly with thy GOD? *Micah 6:8..*

Micah 6: 8. Bookhand with uncial initials in red. Original 12'' x 16''. In possession of Edward S. Brown, Jr., Albuquerque. Ralph Douglass. 1957.

the

FORTY-FOURTH

fiesta

OPEN-DOOR EXHIBITION

show

AUG. 18 THRU OCT. 2, 1957

Exhibition catalog cover. Spanish Round Gothic, printed in blue on yellow stock with Garamond Roman type in black. Used by permission of the Museum of New Mexico. Ralph Douglass. 1957.

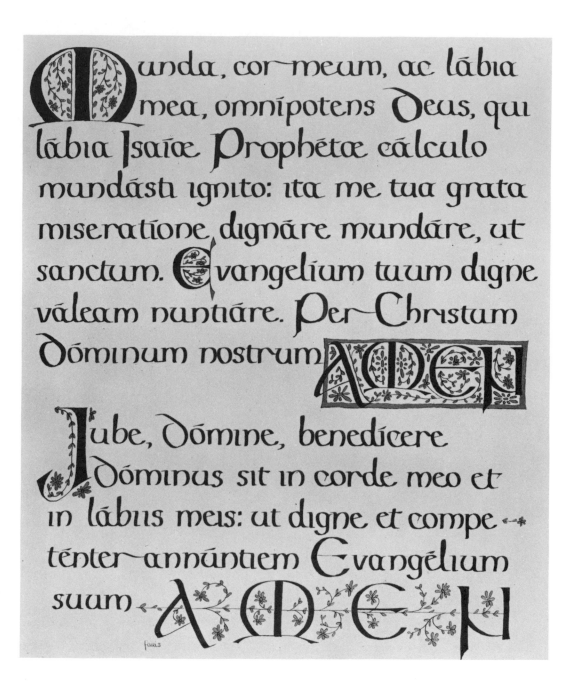

Munda, cor meum, ac lábia
mea, omnípotens Deus, qui
lábia Isaiæ Prophetæ cálculo
mundásti ignito: ita me tua grata
miseratione dignáre mundáre, ut
sanctum. Evangelium tuum digne
váleam nuntiáre. Per Christum
Dóminum nostrum AMEN

Jube, Dómine, benedícere
Dóminus sit in corde meo et
in lábiis meis: ut digne et compe
ténter annúntiem Evangélium
suum AMEN

(This plate and the three following are the work of University of New Mexico art students in a 3-semester-hour course in calligraphy, prerequisite to which were two introductory courses in pen and brush lettering.) Early Uncial. Illumination in gold and black. Original 13″ x 17″. Margaret Faris Bangston. 1954.

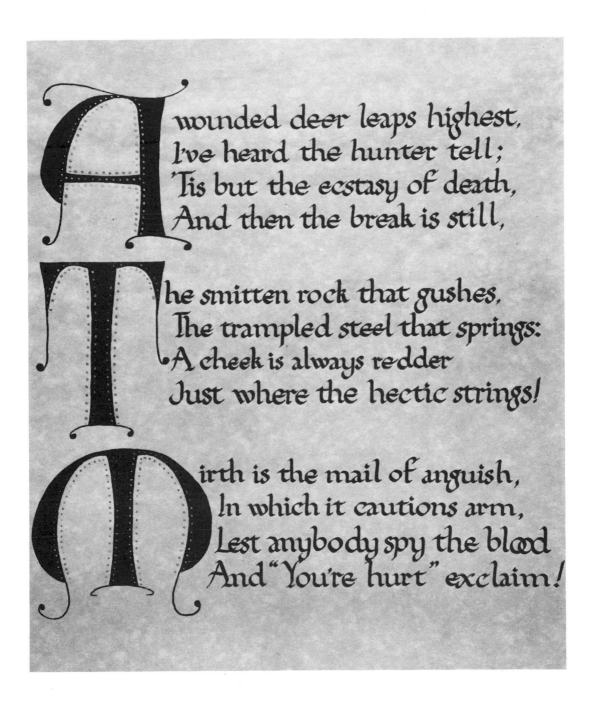

A wounded deer leaps highest,
I've heard the hunter tell;
'Tis but the ecstasy of death,
And then the break is still,

The smitten rock that gushes,
The trampled steel that springs:
A cheek is always redder
Just where the hectic strings!

Mirth is the mail of anguish,
In which it cautions arm,
Lest anybody spy the blood
And "You're hurt" exclaim!

Bookhand with Lombardic initials, on paper parchment. Gold and black. Original 17″ x 19½″. (Margins cropped in reproduction to enlarge lettering.) Work of a football player, Herbert Caudle-Grossman. 1954.

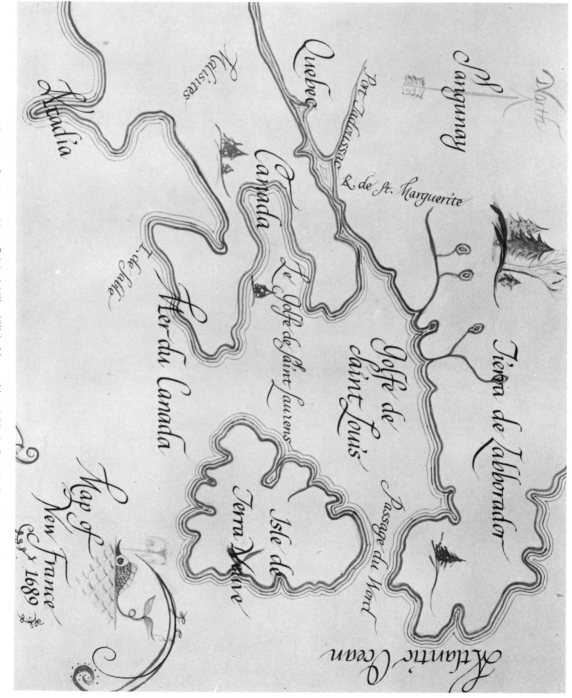

Chancery Cursive on Map. Original 14'' x 17'' in blue, gold and black. Beverly Orr Stringer. 1956.

Padre nuestro que estás en los cielos, santificado sea tu nombre.

Venga tu reino. Sea hecha tu voluntad, como en el cielo, así también en la tierra.

Danos hoy nuestro pan cotidiano.

Y perdónanos nuestras deudas, como también nosotros perdonamos a nuestros deudores.

Y no nos metas en tentacion, mas libranos del mal: porque tuyo es el reino, y el poder, y la gloria, por todos los siglos.

Amen

Spanish Round Gothic with Lombardic initials. Illumination in blue, red and gold. Original 14'' x 17''. (Margins cropped.) Myrle Van Atta Redmond. 1957.

NOTES

(To demonstrate the use of the following master sheets, we have inserted here some practice pages to try your pen on. Tear them out as used. Finally, tear out the master-sheet and use it under 16 or 20-lb. bond practice paper with larger margins.)

Master sheet for Roman with Esterbrook #18 or Speedball C-1 pen. Use with wider margins.

or Italic with Iridinoid or Osmiroid "Broad" pen.

index